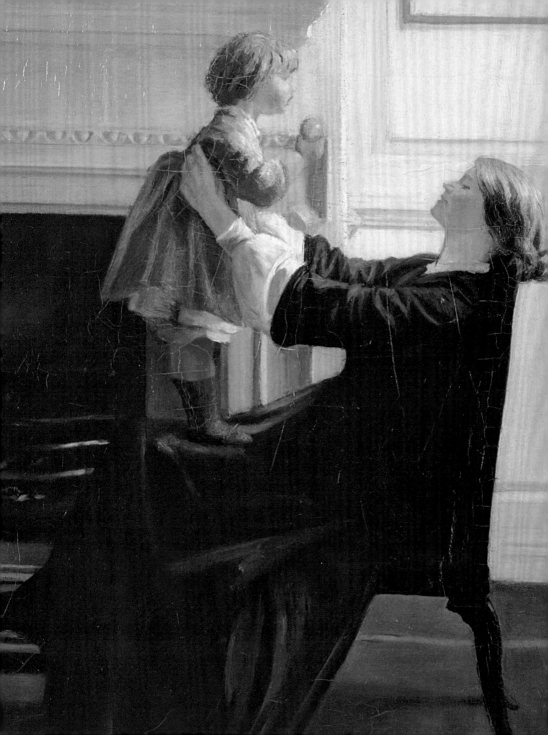

ANN COXON

Motherhood

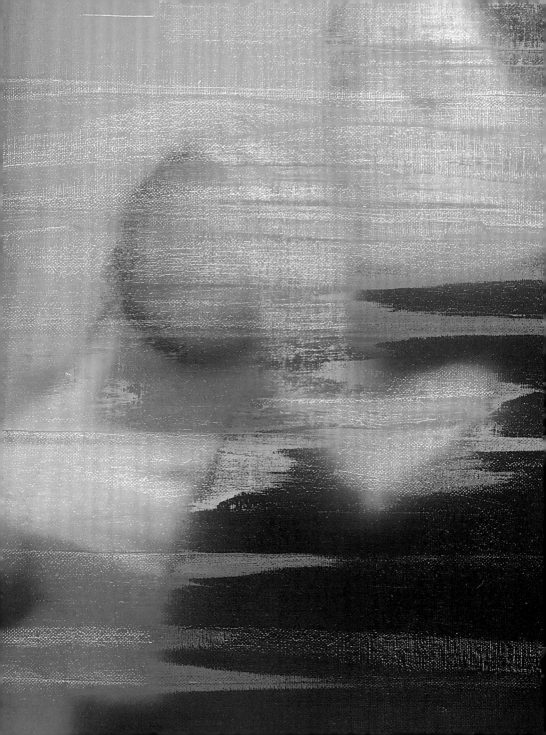

Representing Motherhood 7

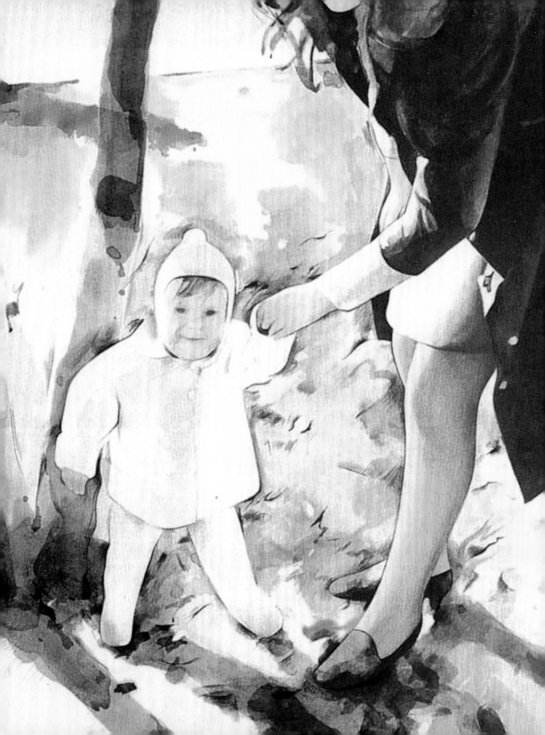

Representing Motherhood

One of the most humbling experiences of my life occurred shortly after the birth of my daughter. Though – like many babies – she had been quiet on our first night together in the hospital, she spent most of her second night crying and unsettled. Bone-tired, weak and teary myself, I fed her, changed her and rocked her until I no longer knew what to do to keep her quiet. To let me rest, a kind nurse took her away for a while, swaddled her and returned her to the crib in a position from which she didn't awake for several hours. At that moment it occurred to me that, although she was my baby, and I was now a mother, I knew very little about motherhood. Or at least, what I thought I knew about mothering was already being put to the test and any romantic notions I had were useless without the practical skills and experience to back them up. Twelve years later, I am still learning.

Culture sends us many messages about what motherhood means; what it should and shouldn't be, how mothers act, how they look, how they feel, what they do and don't do. Many of them prove unhelpful to a new mother with a steep learning curve ahead – perhaps even more so for those whose journey into parenthood does not follow heteronormative circumstances, or for primary carers who may not even identify with the term 'mother'. For someone educated in the feminist and psychoanalytic theories that have explored the mother/child relationship and informed the history and making of art for several decades, the lived reality of motherhood was more of a shock to me than anticipated. Waves of emotion changed with alarming frequency from joy to sadness, hope to grief, calm to anger and back again. When the art historian turned psychotherapist Rozsika Parker (1945–2010) wrote about maternal ambivalence in her groundbreaking book *Torn in Two* (1995), she noted that:

Richard Hamilton *Mother and Child* 1984 (detail). See p.111.

7

How a mother feels about mothering – or the meanings it has for her – is heavily determined by ... cultural representations of motherhood ... Becoming a mother inevitably entails encountering dissonances and disjunctions between the lived experience of mothering and the sometimes contradictory yet usually prescriptive or normative ideals that mediate mothering.[1]

Motherhood is a subject with a long, rich and varied history of representation in art. Art may be a carrier of normative ideals, or it may be the means to overthrow them. Yet it would be simplistic to assume that pre-modern art history offers us only idealised pictures of motherhood, or indeed that only in recent years have artists questioned those ideals in favour of presenting differing views of motherhood. This book brings together a selection of artworks that depict motherhood in various ways. Spanning over four centuries, these artworks share common themes or ideas which form the basis of each chapter. Rather than choosing artworks to illustrate particular issues, the works are grouped according to the themes they themselves suggest. The images are sometimes surprising, sometimes affirming. What is striking is the diversity of approaches, both to the central idea of motherhood, and to the particular types of mother or mothering explored.

The first chapter presents portrayals of divine mothers. Undoubtedly the most familiar and widespread depiction of motherhood in European and South American cultures is the iconic image of the Virgin Mary. Surrounded by symbolism, she has been seen to represent such values as love, devotion, chastity, faithfulness and, of course, divinity. Mary is a vessel for God's divine love in the form of the Christ child. She symbolises an unattainable ideal and is largely seen as a passive 'container' or carrier of meaning. Despite the predominance of these Marian images of maternity, artists have pictured alternative concepts of the divine mother, inspired by ancient myths and goddesses and other pre-Christian or indigenous concepts of Mother Earth. Second-wave feminists, in particular, drew upon

age-old notions of maternity in their rejection of patriarchal culture and attempts to reimagine a matriarchal world-view. In recent years, representations of Gaia or Mother Earth are gaining traction once again in the face of the climate crisis and our increased awareness of the environmental consequences of human development.

Though gender identities are increasingly fluid, women's bodies are still bound by their biological potential, their fertile years punctuated by menstruation, and/or marked by conception, pregnancy, birth and breastfeeding.[2] While these 'facts of life' do not preclude those who cannot – or choose not to – conceive naturally from motherhood, they continue to shape the complex relationships of women to their bodies. It is therefore no surprise that women artists return, time and again, to the embryonic, pregnant or lactating body as rich ground from which to explore their own generative creativity. In the twentieth century, artists such as Eileen Agar, Grace Pailthorpe and Magdalena Abakanowicz (none of whom became biological mothers) imagined the embryonic development of new life and its relationship to the womb, the psyche and matter (pp.30–1, 33 and 35). Agar and Pailthorpe were associated with the surrealist movement, Abakanowicz with the New Tapestry movement, which she led by developing ambitious, soft, organic forms from plant fibre. While these artists pictured embryonic life, art history gives us relatively few depictions of the pregnant body as seen from the outside. Existing examples are therefore striking and much referenced, as, for example, in Paula Modersohn-Becker's nude and apparently pregnant *Self-portrait on the 6th wedding anniversary* 1906 (p.29) or Marc Quinn's *Alison Lapper, 8 months* 2000–12 (p.39).

More commonly, artists have depicted mothers with their newborn offspring. One of the most unusual, memorable paintings of new mothers included here is *The Cholmondeley Ladies* c.1600–10, an early seventeenth-century portrait of two women sitting upright and fully dressed in bed, each holding a baby (p.42). Over the centuries, society portraits were commissioned

as a record of family members and important heirs. These mothers were doing their ancestral duty. In the nineteenth century, artists began to paint more moralistic scenes full of symbolism and allegory. In an age where many women died in childbirth or faced destitution, becoming a mother was an especially risky business. Benefiting from medical and social advancement in the twentieth century, women began to make choices about having children and/or dedicating themselves to a career. Contraception and feminism both played their part in liberating women from the shackles of home and family, enabling many to nurture other areas of life.

Artist Caroline Walker paints carefully observed scenes of women going about their domestic duties. A recent series documents her sister-in-law at home with her newborn, providing a glimpse inside the largely housebound and sleep-deprived early days of motherhood (pp.59–61). While women may have historically benefited from the proximity of older generations to assist with child-rearing, in Western societies it has become common for many new parents to find themselves isolated, without the support of parents, grandparents and/or the wider community. For mothers, this increases the risk of postnatal depression or anxiety – with changes to hormone levels, fatigue, social pressure and psychological factors providing the perfect storm. Yet this is not a new phenomenon. Depressed, paranoid mothers can be found in literature and film, from Charlotte Perkins Gilman's nineteenth-century claustrophobic postpartum protagonist in *The Yellow Wallpaper* (1892), to the horrors of *Rosemary's Baby* in 1968.

Women artists – like women in other careers and professions – have wrestled with the often-clashing desire to work and to procreate, wondering how they will juggle responsibilities or make ends meet. While Paula Modersohn-Becker may have felt this as keenly in 1906 as women artists do now, her choices were perhaps more limited. The desire or expectation to 'have it all' is a later twentieth-century invention. Childcare is, however, costly and the majority of working mothers find that

the burden of domestic responsibility often falls to them. For artist mothers, the need for unstructured time and space in which to create can leave them haunted by Cyril Connolly's infamous statement that, 'There is no more sombre enemy of good art than the pram in the hallway.'[3] Even before feminist artists turned their domestic confinement into the subject of their art practice, Barbara Hepworth – 'accidental' mother of four (she gave birth to triplets) – found ways in which to merge home and studio arrangements (p.43). The rise of conceptual art and photography enabled artists such as Mary Kelly and Catherine Opie to document their own situation as new mothers, embodying the positions of both artist and mother and shining a light on their multi-faceted identities and relationships (pp.46–9 and 55). Others, such as Zineb Sedira and Anna Maria Maiolino, have explored their positions as both mother and daughter, tracing a culturally and geographically shifting matrilineal heritage (pp.70 and 71).

While women artists have begun to explore their lived experiences as mothers in the twentieth and twenty-first centuries, there is a parallel (and perhaps more traditional) phenomenon of artists depicting their own mothers. Ageing mothers sitting stoically for portrait studies can be found throughout the history of Western art. The works selected here range from the carefully observed paintings and drawings of Lucian Freud (p.65) to multimedia sculpture and installation by Keith Edmier and Ilya Kabakov (pp.67 and 69). These expanded forms of portraiture are testament to cultural, social and political circumstances, as well as the physical and personal. Using lens-based media, Rosalind Nashashibi and D'Angelo Lovell Williams have put two generations in the picture, exploring the intimate bond between mother and child that endures into adulthood and in the face of differing circumstances (pp.73 and 75).

No book on motherhood and its representations could avoid considering the figure of the nurturing, protective mother. Images of nursing mothers are almost synonymous with the idea of nurture and the sustaining 'milk of human kindness'.

There is, however, a darker side to the fierce maternal drive to care and to protect. Louise Bourgeois's landmark sculpture *Maman* presents us with an image of the archetypal protective mother (p.93). But rather than taking human form, she towers over us in the shape of a giant spider, at once menacing and awesome. Faced with poverty and hardship, the mundane and often tedious work of child-rearing and home-making is accompanied by high levels of anxiety and almost constant struggle. Dorothea Lange documented the impact of hard times as imprinted on the face of her *Migrant Mother* (p.85). The difficult existence of a mother raising children against the odds could equally be found in the East End of London in the 1970s (as it was for the Hackney Flashers, p.91) or indeed in present-day Britain, where high inflation, increasing interest rates and a lack of affordable childcare are once again sparking a cost-of-living crisis for millions of families.

'Grief …' as national matriarch the late Queen Elizabeth II once said, ' … is the price that we pay for love'. Those longing to be parents experience the deep grief of pregnancy loss or infertility, as expressed so poignantly by artists such as Tracey Emin (p.99). Käthe Kollwitz's images of grieving mothers speak of the devastations of war and the price paid through human suffering (p.98). Experience of loss may be almost universal, but Titus Kaphar's striking image of a grieving Black mother reminds us that some lives may be more at threat than others (p.101). While these images of motherhood represent collective grief and social injustice, art also presents us with more prosaic family portraits.

With the advent of photographic portraiture, a fashion for photographing babies in the late Victorian era has recently drawn attention from collectors of the resulting 'hidden mother' photographs. Holding their offspring still, yet hidden behind draped clothes and furniture, we see only hints of these women – a hand or a sleeve just poking out into view. What appears to the contemporary eye as a sinister situation is in fact the result of proud mothers wanting to freeze a moment

in time (pp.104–5). *'Mother's Pride'* is the title of a photograph by Dennis Morris, showing a Black mother and her children in 1970s Britain (p.109). It is also, of course, the name of a well-known brand of (usually white) sliced bread, intentionally invoking images of wholesome family life and mother baking in the kitchen. Black British families were underrepresented in the advertisements of the 1970s, but Morris's photograph captured this mother's pride and desire to belong. Family pride is no less keenly felt in Aliza Nisenbaum's painting *Susan, Aarti, Keerthana and Princess, Sunday in Brooklyn* 2018 (p.113). Here a mixed-heritage family of two mothers and their adopted daughters share a cosy moment, showing that family values such as love and equality are sustained while the 'nuclear family' unit takes on new forms.

Beyond the joyful moments, love and pride undoubtedly coexist with feelings of frustration or anger. Returning to the notion of maternal ambivalence, the aspect of motherhood most threatening to normative ideals may be – as Rozsika Parker suggested – a mother's struggles with mental and emotional division from her offspring. In exploring this territory, art can show us a truer picture of motherhood. While artists such as Louise Bourgeois, René Magritte and Dorothea Tanning have created surreal and psychologically loaded images of maternity allowing for divided emotional states (pp.93, 117 and 119), others, such as Gillian Wearing, Mona Hatoum or Damien Hirst present an even bleaker picture. Wearing's *Sacha and Mum* focuses on a mother's abusive violence towards her daughter (p.122), while the harsh divisions of physical separation and death are explored by Hatoum and Hirst (pp.121 and 123).

Such nightmarish visions of maternal division serve as reminders that while the majority of mothers may be far from ideal, they are also – to use psychoanalyst D.W. Winnicott's term – 'good enough'.[4] To be good enough is of course more healthy, and more achievable, than ideal or perfect. This is what most mothers quickly learn: that representations of motherhood can never quite capture the full picture of lived experience.

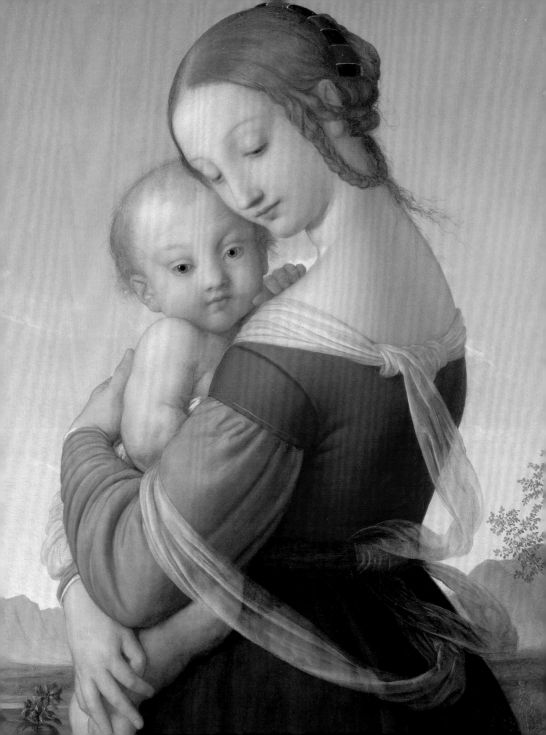

Divine Mothers

William Dyce 1806–64
Madonna and Child c.1827–30
Oil paint on canvas 102.9 × 80.6

This painting provides a snapshot of idealised motherhood from the early 1830s. William Dyce's Madonna and child are a highly stylised duo. Inspired by fifteenth-century Italian painting, the Virgin Mary and Baby Jesus are portrayed with the pale skin and fair hair of Europeans and set against a classical landscape. Despite their religious importance, however, this Madonna and child are presented in a relaxed pose, without overt symbolism. Her hairstyle and clothing are indicative of the Victorian fashions of the artist's era. The baby looks secure in his mother's arms, and she rests her cheek on his head while holding his tiny foot in her fingers. Clear skies and bright colours add to the feeling of serenity.

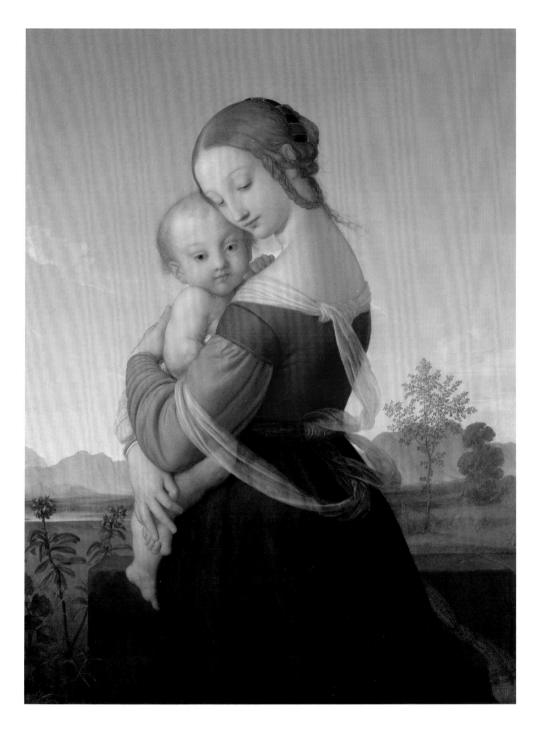

George Frederick Watts 1817–1904
The All-Pervading 1887–90
Oil paint on canvas 213.5 × 112

George Frederick Watts described this eerie, allegorical figure as 'the all-pervading Spirit of the Universe'.[5] Appearing to float within a vaginal or womb-shaped space created by arching wings, she has in her lap the 'globe of systems': a kind of crystal ball for seeing the secrets of all that is. Watts's symbolist painting conjures up an all-seeing oracle, who could equally represent Mother Earth or Gaia, holding creation and its mysteries in her hands.

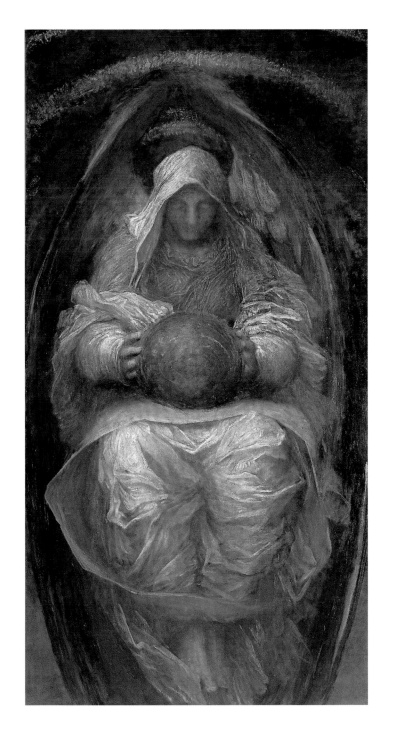

Monica Sjoo 1938–2005
God Giving Birth 1968
Oil paint on board 15.2 × 10.2

When it was first exhibited in Cornwall in 1970, this now iconic feminist painting was deemed to be blasphemous and removed from the wall. The artist was inspired to paint the 'Great Mother' after her experience of the natural home birth of her second son: 'This birth changed my life and set me questioning the patriarchal culture we live in and its religions that deny the life-creating powers of the mothers.'[6] The Great Mother is presented as 'the Matrix of cosmic creation'. She represents a connection to ancient matriarchal cultures and the deep time of the universe.

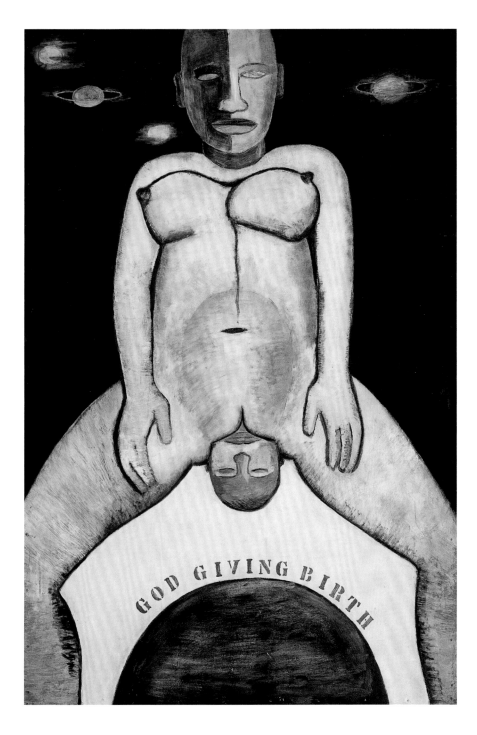

Nancy Spero 1926–2009
Sheela-na-gig/Artemis: Totem 1 1985
Hand-printed collage on paper 276 × 53

This printed paper scroll by artist and activist Nancy Spero
brings together some powerful female archetypes. Sheela-
na-gig – the Celtic goddess of fertility – squats in a birthing
position, confronting us with her exaggerated vulva. She sits
alongside female figures from Egyptian tombs and Artemis,
the Greek goddess of hunting, childbirth and the moon, whose
bow and arrow have been removed to suggest a defiant gesture.
Spero's collaged goddesses are strong, active, creative bodies
to fear and revere.

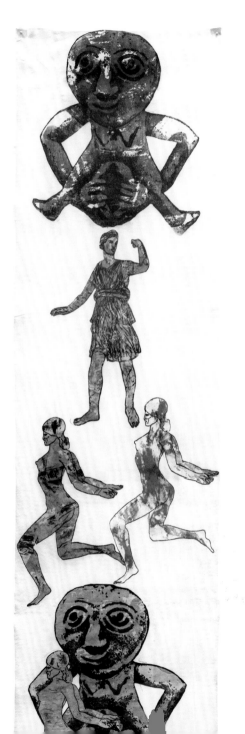
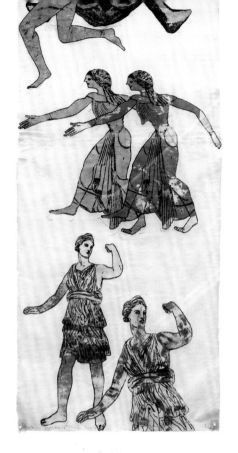

Embryonic Mothers

Marcus Geerearts II 1561/2–1636
Portrait of a Woman in Red 1620
Oil paint on oak 114.3 × 90.2

Pregnancy portraits were surprisingly fashionable in Jacobean
Britain, when women spent a significant portion of their lives
pregnant and many died young in childbirth. Still considered
the property of fathers and husbands, those of the upper
classes were expected to produce family heirs. The sitter here
is thought to be Anne, daughter of Sir William Roper and wife
of Sir Philip Constable. The opulent red and gold textiles of her
dress and surrounding drapery are a clear sign of wealth and
status. Lace, brocade and velvet envelop her. Anne rests a hand
over her bump in a seemingly relaxed manner, giving no hint
of whatever conflict or discomfort she may have felt beneath
the carefully crafted adornments.

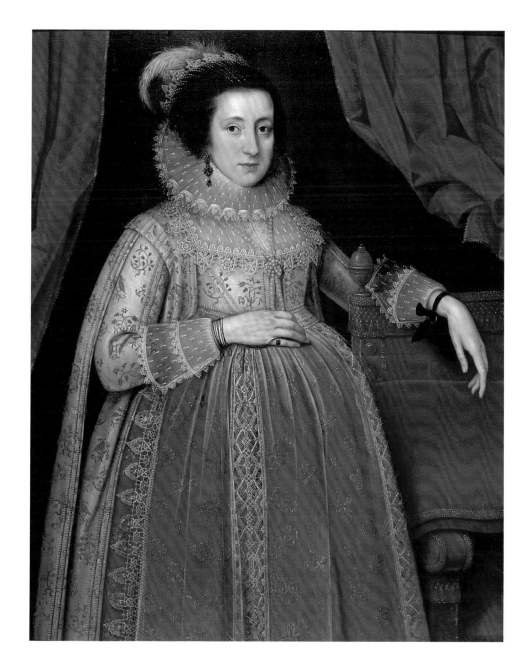

Paula Modersohn-Becker 1876–1907
Self-portrait on the 6th wedding anniversary 1906
Oil paint and tempera on cardboard 101.8 × 70.2

Hailed as the first nude female self-portrait in Western art history, this painting was made before Paula Modersohn-Becker was pregnant, though she certainly appears to be admiring her swollen belly. One interpretation is that she was 'trying on' the state of becoming a mother. Another is that she wished to portray herself as a creative, fertile figure. Her letters and writings of the time suggest that she was ambivalent about the prospect of motherhood. In 1906, when this self-portrait was painted, Modersohn-Becker had separated from her husband, though they reunited the following year when she became pregnant with their daughter Mathilde. Sadly, only days after giving birth the artist died of an embolism, likely brought on by too much prescribed postnatal bed-rest.

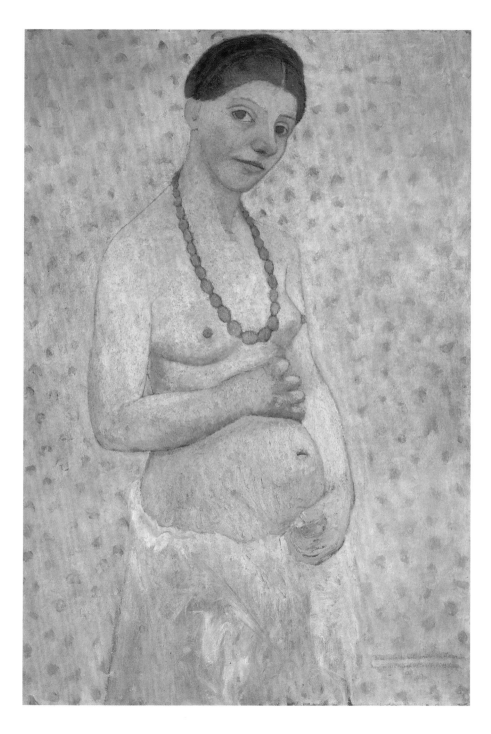

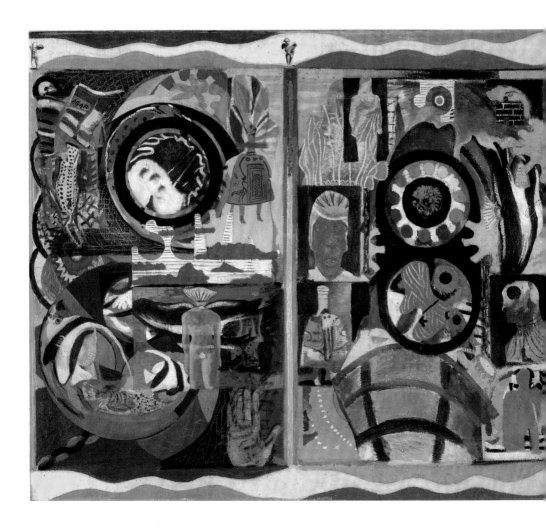

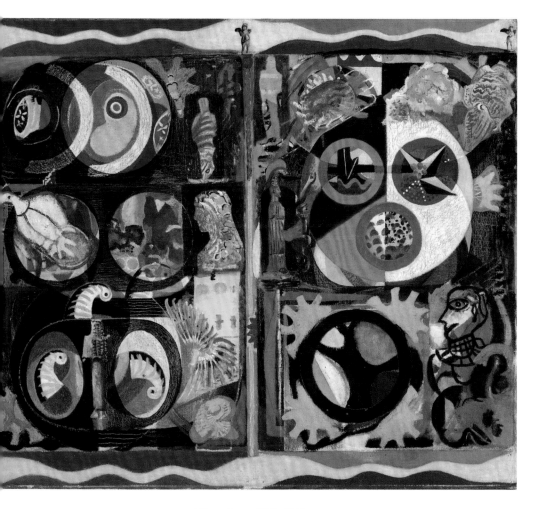

Eileen Agar 1899–1991
The Autobiography of an Embryo 1933–4
Oil paint on board 21.3 × 91.4

This colourful painting in four sections is a celebration of life and
its biological development. Eileen Agar – who never became a
mother herself – was interested in representing 'a feminine type
of imagination'[7] and believed that the surrealists' turn to the
unconscious mind suggested a kind of 'womb magic'.[8] Agar was
interested in birds, fossils and marine life. She was particularly
fascinated to learn that human embryos have gills in the early
stages of their development.

Grace Pailthorpe 1883–1971
May 16, 1941 1941
Oil paint on canvas mounted on board 30.3 × 40.5

Grace Pailthorpe's surrealist representation of a reclining
foetus seems as shocking today as it must have at the time of
its creation (the date is taken as the work's title). This strange
creature with its developing arms and genitalia floats in a blue
landscape, attached at top left to a placenta and with bizarre
additional elements, such as claws and a red bird/horse-like
figure. Brash colours add to the nightmarish quality of the
painting. Pailthorpe originally trained as a surgeon before
studying psychology and psychoanalysis. This is one of the latest
paintings in a series relating to her interest in the development
of the psychological subject within the earliest stages of life,
including within the womb.

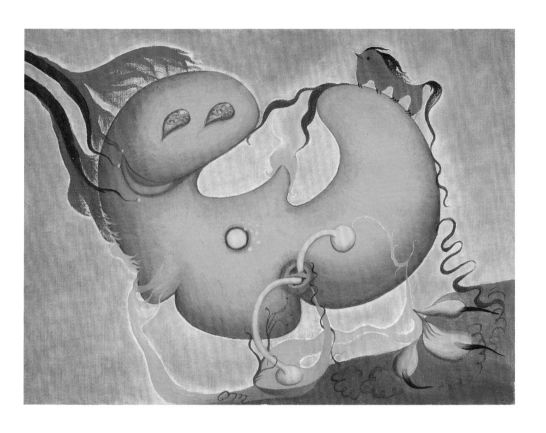

Magdalena Abakanowicz 1930–2017
Embryology 1978–81
Burlap, cotton gauze, hemp rope, nylon and sisal
Dimensions variable

Hundreds of rounded forms make up this soft sculptural
environment. Magdalena Abakanowicz spoke of her need
to create 'bellies, organs, an invented anatomy'.[9] The artist
gathered old clothing, sacks, stockings and string to
create a series of stuffed, stitched and bound objects.
Like cocoons or root vegetables, these mysterious forms
seem to be holding within themselves a store of energy
and the potential for new life to spring forth from within.

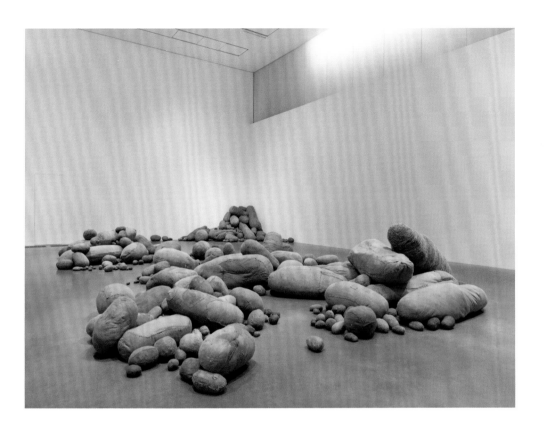

Laura Aguilar 1959–2018
Clothed/Unclothed #30 1994
2 photographs; gelatin silver prints on paper
48.3 × 38 and 48.2 × 38.4

Chicana artist Laura Aguilar created this photographic diptych
as part of her series *Clothed/Unclothed*. Aguilar photographed
mothers, lovers and others who fall outside of heteronormative
ideals, raising levels of visibility and representing diversity. Working
closely with her subjects, she photographed them both clothed
and naked. This lesbian couple are clearly expecting a baby.
Posed in positions often adopted for classic couples' portrait
photography, they look directly at the camera unapologetically.

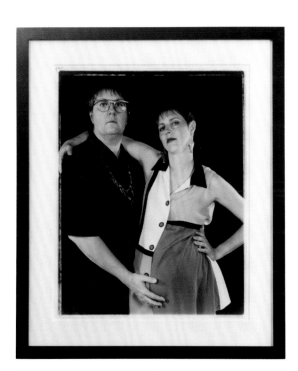

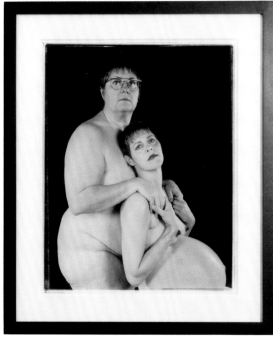

Marc Quinn 1964–
Alison Lapper, 8 months 2000–12
Marble and plinth 83.5 × 40.5 × 65

Marc Quinn's portrait of Alison Lapper was seen as a landmark
representation of disability, female strength and creativity when
it occupied the Fourth Plinth in Trafalgar Square in 2005. The
statue was carved from a twelve-foot block of Carrara marble
and remained on display for two years. Later, inflatable versions
were seen at the London Paralymic Games in 2012 and at the
Venice Biennale. Though initially reluctant, Lapper was heavily
pregnant with her son when she agreed to model for Quinn.
An artist herself, Lapper has spoken of her son (who sadly died
in 2019) as her greatest creation.

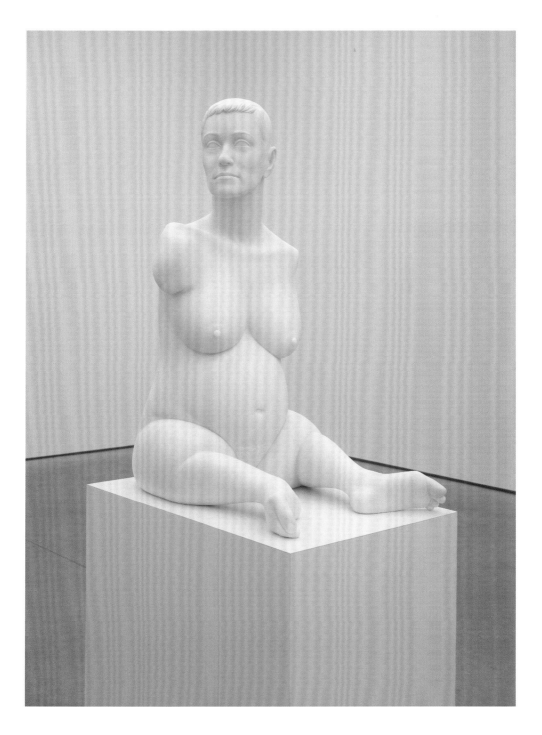

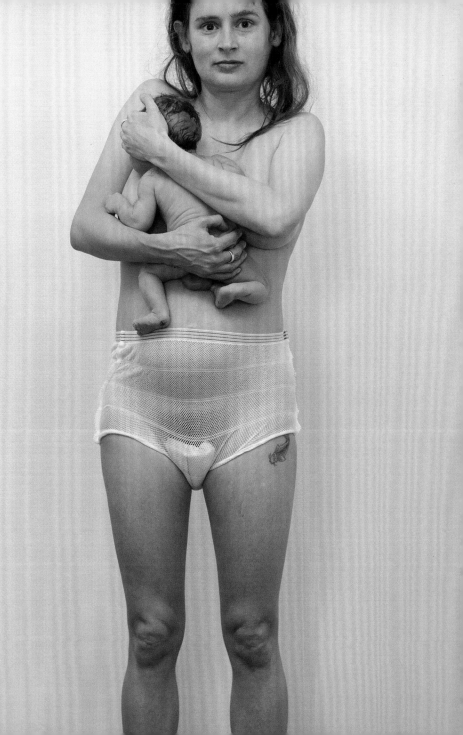

New Mothers

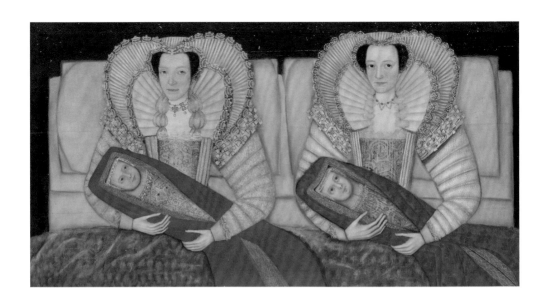

Unknown artist, Britain
The Cholmondeley Ladies c.1600–10
Oil paint on wood 88.6 × 172.3

According to an inscription on the bottom left of the painting,
these are 'Two Ladies of the Cholmondeley Family, Who were
born the same day, Married the same day, And brought to Bed
[gave birth] the same day'. It's unclear whether these mothers
are twins or sisters, or simply women who married into the
Cholmondeley family. At first appearing to be identical, the
women have different eye colours and features, as do their
babies, who are wrapped in red christening robes. The painting
presents us with a game of 'spot the difference' as we notice
small details on the ladies' clothing and jewellery. Whoever they
were, these women and their infants fit the mould. Motherhood
has never looked so formulaic.

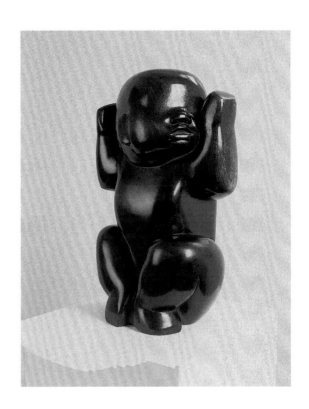

Barbara Hepworth 1903–75
Infant 1929
Wood 43.8 × 27.3 × 25.4

Barbara Hepworth's first son Paul was born in 1929, the year
she carved this dark wood sculpture of a baby. The infant is in
a natural sleeping position, though the artist chose a vertical
presentation, using characteristically rounded and simplified
forms to balance the structure and to represent the limbs,
torso and head. Hepworth gave birth to triplets in 1934.
Although she believed that 'being a mother enriches an artist's
life',[10] there is no doubt that she struggled to find a balance
between her responsibilities as a mother of four and her
continuing drive to create art.

Ford Madox Brown 1821–93
'Take Your Son, Sir' ?1851–92
Oil paint on canvas 70.5 × 38.1

Many interpretations have been offered of this well-known,
yet unfinished painting by Ford Madox Brown. The woman
is thought to be his wife, holding their baby son who sadly
died at ten months old. But the painting's title suggests that
rather than being a tender portrait it has a moralistic concern.
On first glance, it appears to depict the Madonna and child,
but the reflection in the halo-like mirror behind the woman's
head reveals a Victorian domestic setting and the figure
of the father. She looks pale and drawn. Perhaps the child
is illegitimate. Or perhaps she's simply feeling the strain
of new motherhood's responsibilities and asking the father
to play his part.

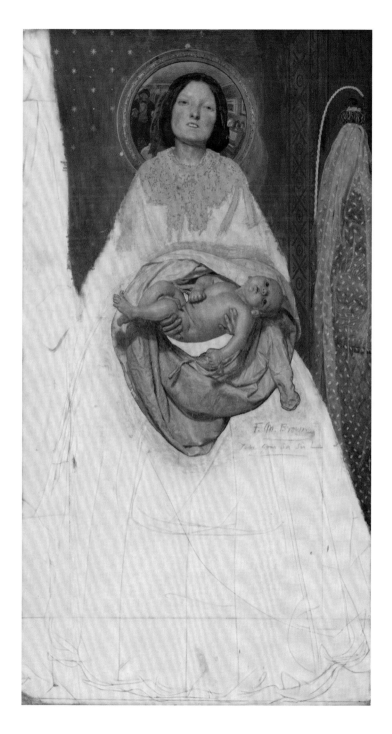

Mary Kelly 1941–
Post-Partum Document 1973–8
13 works on paper; graphite, crayon, chalk and printed
diagrams, mounted on paper 28.6 × 36.1 (each)

Mary Kelly's *Post-Partum Document* is one of the most
ambitious and complex attempts by an artist to represent the
experience of becoming a mother. Beginning shortly after the
birth of her son in 1973, Kelly documented aspects of their daily
routines and developing relationship for the first six years of
his life. Drawing on feminist and psychoanalytic theories, she
brought into focus the contradictions between being an artist
and being a mother, exploring her lived experience and her
analysis of that experience. Details are shown overleaf.

V DP.

D **C**

15.11.75	R1	15.11.75	R2	22.11.75	R3

10.1 I wanna see it. (climbing up on my desk after the slides)

WHY DOES HE INSIST ON GETTING UP ON THE DESK WHENEVER I'M NOT LOOKING. I RESORT TO "DADDY WILL BE ANGRY" TO GET HIM OFF.

10.2 Take my shoe off (trying to untie laces)

I SURPRISED HIS CO-OPERATING IN GETTING READY FOR BED.

10.3 Why you taking da shoe off? (sees me take my shoe off)

I LIKE TO LAY DOWN WITH HIM TO READ STORIES ALTHOUGH R DISAPPROVES.

10.4 Get da pidow. Not dat one, da big one (pointing towards his bed)

I JUST BROUGHT HIM A PILLOW BUT IT'S NOT THE 'RIGHT ONE'. I DON'T EVEN KNOW WHAT PILLOW HE'S TALKING ABOUT.

10.5 Get da tory now, I wan dat one!

HE'S BOSSING ME AROUND. HE'LL JUST HAVE TO READ THE STORY I CHOOSE THIS TIME. (I'M TRYING NOT TO BE WEAK).

10.6 No more tories. (imitating me)

I'M TRYING TO GET HIM TO SLEEP. I WISH HE WAS MORE MANAGEABLE.

10.7 Gapes no good (commenting on his hiccups)

I SURPRISED HE REMEMBERS THAT HE WAS SICK THE LAST TIME HE ATE GRAPES.

[Handwritten column, 22.11.75 — largely illegible cursive]

A **B** **G** 10S2 28 MOS.

48

D C

27.9.75	R1	27.9.75	R2	4.10.75	R3
3.1 Come'n do it (wants to fly the kite)		I SAY IT WOULD BE NICE TO TAKE IT OUTSIDE AS IT'S VERY WINDY BUT IT'S ALSO VERY LATE SO I TRY TO CHANGE THE SUBJECT.			
3.2 Down dis, it's falling. (I'm pretending to fly kite)		AS I STARTED THIS GAME OF PRETENDING TO FLY THE KITE STANDING ON A CHAIR HOLDING IT AND MAKING SOUNDS LIKE WIND, NOW I'M STUCK WITH IT.			
3.3 Ask Daddy flying the kite, go ask him. (I say Daddy will fly it tomorrow)		HE REMEMBERS PROMISES VERY WELL.			
3.4 Do potty now (asking me to get pot)		WHY DOES HE ASK ME TO GET THE POT AND THEN REFUSE TO SIT ON IT.			
3.5 Where 'tories gone (trying to postpone bedtime)		HE SEEMS TO SPEAK LESS CLEARLY NOW BUT MORE OF IT.			

I've been concerned about his health since Tuesday when he drank half a bottle of liquid aspirin and we had to rush him to the hospital (& possibly on treating his teeth) and we left it on the kitchen table when it was time for baby's sleep, anyway, the doctor said he was alright but that he did have had tonsilitis. I wonder how long he had it and why I hadn't noticed it myself. Sometimes I forget to give him his medicine which makes me feel totally irresponsible or I just feel I wish it was all over, he was growing up but my mother says it never ends, the worry just goes on and on. Since he wasn't well he's been staying home from nursery. Anyway, he had been saying not to school everyday and last week I suppose I something felt like that myself about going to work.

A B G 3S9 26 MOS.

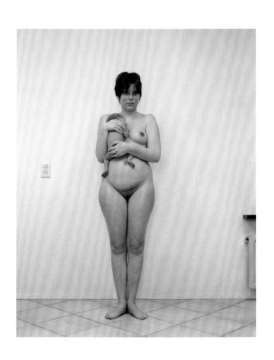

Rineke Dijkstra 1959–
Julie, Den Haag, Netherlands, February 29 1994 1994
Tecla, Amsterdam, Netherlands, May 16 1994 1994
Saskia, Harderwijk, Netherlands, March 16 1994 1994
From the *New Mothers* series
3 photographs; chromogenic prints on paper, mounted on
aluminium 117 × 94 (each)

These photographic portraits were created one hour, one week
and one day after the women had given birth to their babies.
Posing naked in their homes for Dijkstra's camera, the women
show vulnerability and strength. This is what new motherhood
looks like. Stripped of clothing and protectively cradling their
naked babies, the women remind us of the raw, biological fact
of the mother's body as the place in and through which all
human life begins.

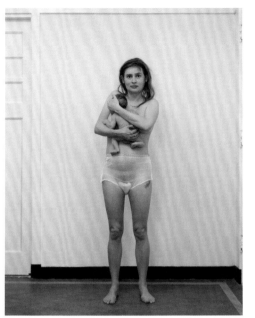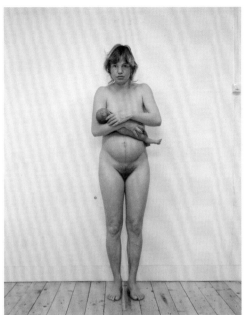

Gerhard Richter 1932–
S with Child 1995
Oil paint on canvas 36 × 41

This is one of a series of paintings Gerhard Richter made of his
third wife Sabine and their newborn son. Characteristic of
Richter's blurred, partially erased oil paintings, the image is at
once intimate and distant. As with much of Richter's art, we are
given a glimpse into his autobiography, albeit as if behind a veil
or screen. As a father, Richter is at a remove from the mother/
child dyad. Like many artists before him he has painted a tender
portrait of his wife and child, yet they are rendered anonymous
by his painterly technique.

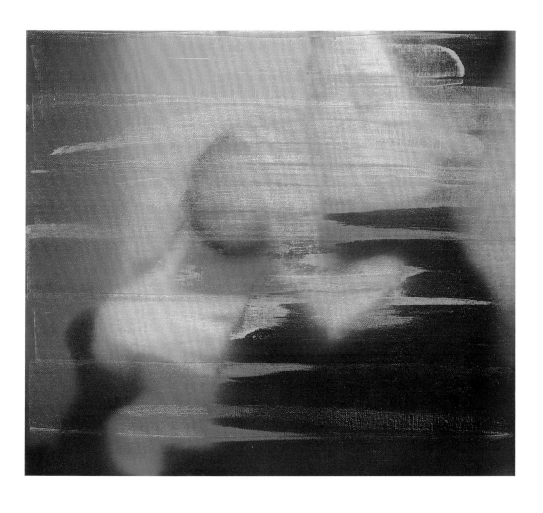

Catherine Opie 1961–
Self Portrait Nursing 2004
Chromogenic print 101.6 × 78.7

In this photographic self-portrait, Catherine Opie presents
an image of maternity which is both classical and subversive.
She is seen gazing lovingly at her infant son who she is
breastfeeding, set against a backdrop of red and gold damask
fabric which recalls the backgrounds of sixteenth-century
portraits by Hans Holbein the Younger (1497/8–1543). In the
early 1990s Opie photographed queer and sado-masochistic
subcultures, addressing her own identity and sexuality.
Though here she presents an image of domestic contentment,
the fading scars on her chest spell out the word 'pervert'.

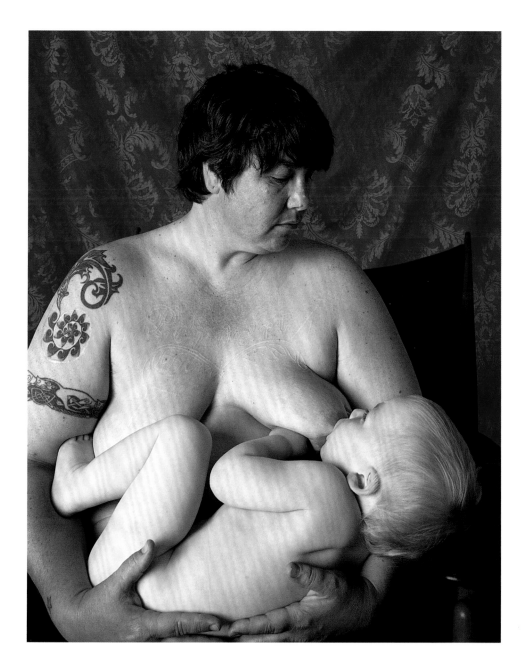

Deana Lawson 1979–
Baby Sleep 2009
Inkjet print on paper, mounted on PVC
63.5 × 76.2

A couple share an intimate moment while the baby sleeps.
Deana Lawson's photographs reveal and celebrate the Black
body. Here, she turns her lens on a domestic scene divided
between a sexy moment (on the left) and the paraphernalia of
life with an infant (on the right): a swing chair, foam mat blocks,
a soft book and a sleeping child. Rust-coloured net curtains
hang at the windows behind them, providing a backdrop to
this most intimate family portrait.

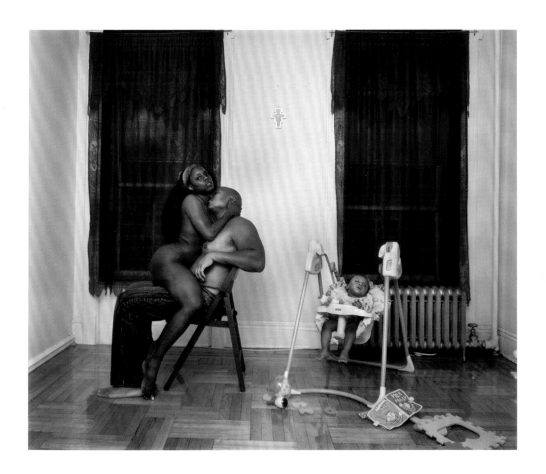

Caroline Walker 1982–
Baby Layla 2022
Oil paint on canvas 75 × 60

Overleaf: *Roundmoor Drive* 2022
Oil paint on canvas 200 × 300

Caroline Walker's paintings show women's mundane domestic
(often unpaid) labour. These two pictures are from a series
documenting the artist's sister-in-law Lisa in the early days
of motherhood. The paintings capture the domestic scenes at
a time when mother and baby necessarily withdraw from the
world and are caught in what seems to be an endless twilight
zone of feeding, changing and sleeping. In *Roundmoor Drive*
(overleaf) we look in through the back doors and window of
a generic red-brick house to see the mother with her baby in
the kitchen. While *Baby Layla* (opposite) focuses more closely
on Lisa and Layla, this could in fact be a portrait of any new
mother and baby.

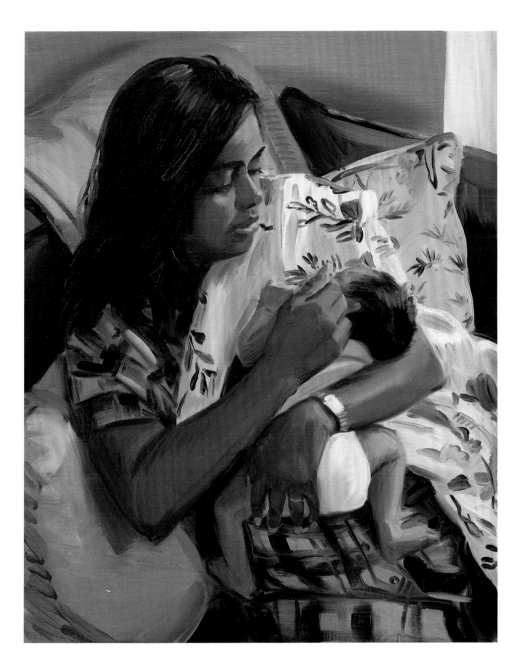

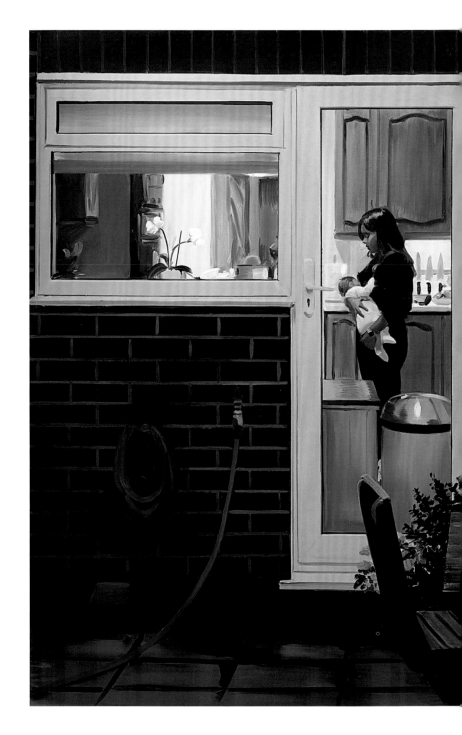

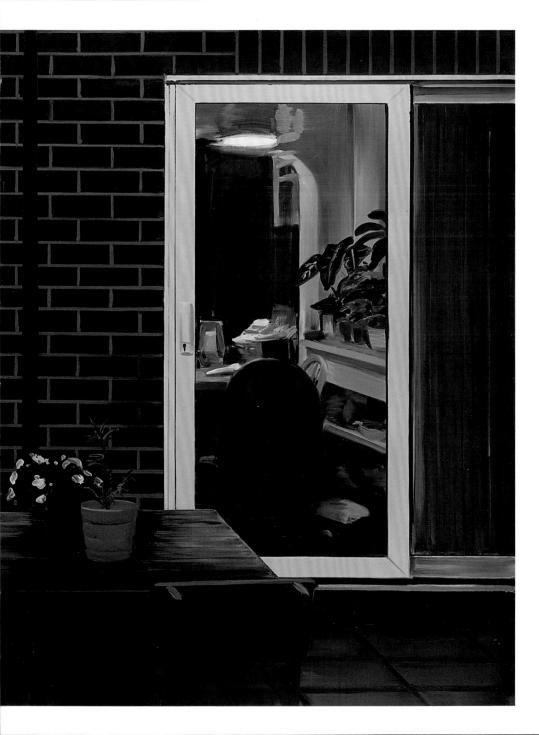

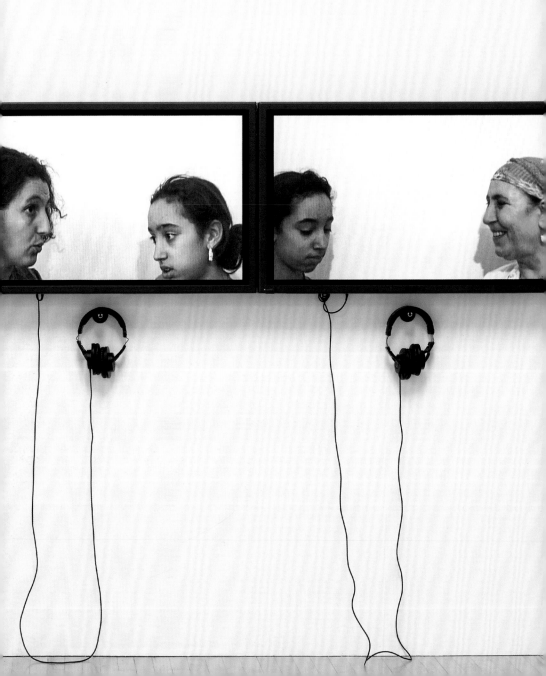

Artists' Mothers

Lucian Freud 1922–2011
The Painter's Mother IV 1973
Oil paint on canvas 27.3 × 18.6

Lucian Freud made eighteen portraits of his mother between
1972 and 1984, asking that she sit for approximately 1,000
hours over the decade. After the death of his father Ernst
Freud, his mother Lucie suffered from depression. The heavy
grey and brown palette used here suggests a melancholic mood.
But there is also a tenderness in the painter's depiction of the
ageing flesh and downcast eyes. Perhaps he saw in her face
the memory of happier days.

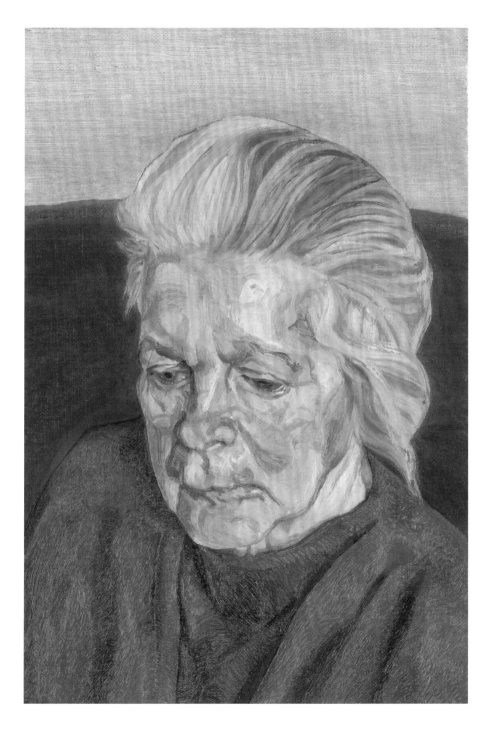

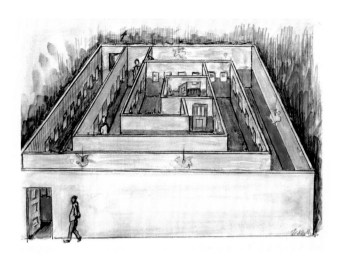

Ilya Kabakov 1933–
Labyrinth (My Mother's Album) 1990
Wooden construction; 9 doors, wooden ceiling props,
24 light bulbs, detritus, audio and 76 works on paper,
photographs, ink and printed papers

Labyrinth (My Mother's Album) is a tribute to Ilya Kabakov's
mother and to all women in Soviet society. The artwork takes
the form of an installation of maze-like corridors leading the
viewer towards an anti-climactic central space (the artist's
sketch above shows the full view of the construction). Along
the corridors, photographs taken by the artist's uncle show
official, state-sanctioned views of the small coastal town of
Berdyansk on the Black Sea in south-eastern Ukraine, where
he lived. These images are juxtaposed with the memoirs of
the artist's mother, revealing a very different lived reality.
This mother's album shows us her struggle to survive through
war and revolution and to protect her children under an
oppressive regime.

Keith Edmier 1967–
Beverley Edmier 1967 1998
Resin, fabric, silicone, rubber and metal 129 × 80 × 67

This life-sized sculpture is a portrait of Keith Edmier's mother.
She is carrying the unborn artist in her clear resin womb, which
she reveals from beneath her clothing. Beverley Edmier's outfit
is based on the powder-pink Chanel suit Jacqueline Kennedy
wore the day her husband was assassinated in Dallas, Texas in
1963. We don't see the woman's features and there is something
ominous about this overtly feminine, all-pink figure gazing at her
developing child. Personal history merges with the cultural and
political here, suggesting that the artist is a child of both his
mother and his time.

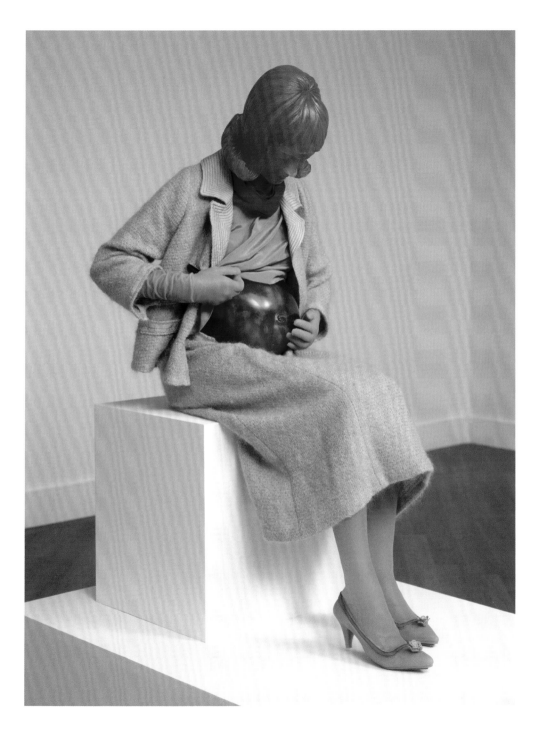

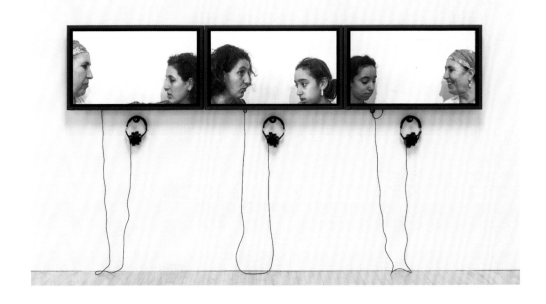

Zineb Sedira 1963–
Mother Tongue 2002
Video; 3 flat screens, colour and sound (stereo), 5 min

Playing over three monitors simultaneously for a five-minute
duration, this video work reflects upon language and cultural
heritage across three generations. Zineb Sedira was born in
Paris to Algerian parents before moving to London, where her
daughter was born. In the video, the artist, her mother and her
daughter try to communicate with one another in their native
languages of French, Arabic and English, testing the connections
between memory and language in the matrilineal line.

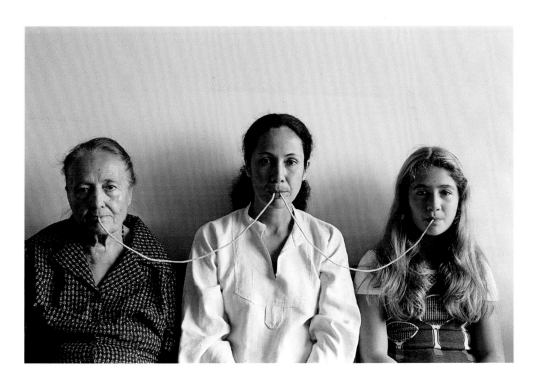

Anna Maria Maiolino 1942–
Por um fio (*By a Thread*), from the series
Fotopoemação (*Photopoemaction*) 1976/2017
Black and white analogue photograph 44.5 × 65
Photographed by Regina Vater

Born in Italy, Anna Maria Maiolino moved with her family
to Venezuela in the 1950s. This photograph from the 1970s
shows the artist seated between her ageing mother and her
young daughter. The women are linked by two long threads,
which they hold in their mouths, demonstrating the maternal
lineage. The artist as mother connects grandmother and
granddaughter, holding both threads in her central position.
These spaghetti-like cords also connect the artist and her
daughter to their Italian cultural heritage.

Rosalind Nashashibi 1973–
Vivian's Garden 2017
Film; 16mm, shown as video, high definition,
projection, colour and sound (stereo) 29 min, 50 sec

Rosalind Nashashibi's film documents the daily lives of two
artists, Vivian Suter and her mother Elisabeth Wild, exploring
their relationship and close bond. At the time of filming,
Suter was in her late 60s, Wild (who died in 2000) in her 90s.
The two women occupied connected houses and a shared
garden in Panajachel, Guatemala, where they were in self-
imposed exile. Nashashibi described the subjects of her film
as 'close as maiden sisters; each is at times mother and
daughter to the other, and sometimes they are my mother
and my daughter too'.[11]

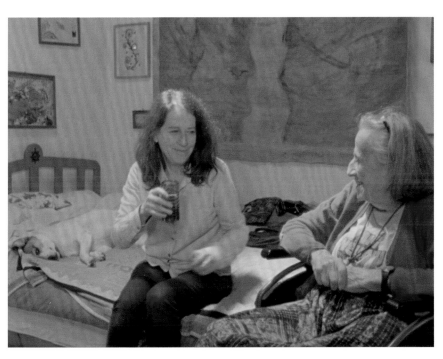

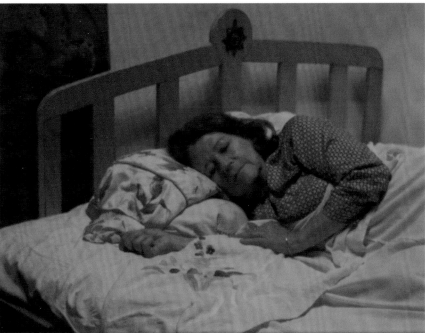

D'Angelo Lovell Williams 1992–
Until We Separate (Mom) 2019
Inkjet print on paper, mounted on aluminium 126.5 × 101.5

D'Angelo Lovell Williams is a queer, non-binary artist.
This photograph shows the artist with their mother in
their grandmother's living room. Williams's head is cradled
in their mother's lap. A string of red chewing gum stretches
between their closed lips, indicating the fragile connection
between parent and child. The artist has said, 'When I present
images about vulnerability and intimacy or race and sexuality,
I know they are not just about me . . . I can build a community
with images in public spaces.'[12]

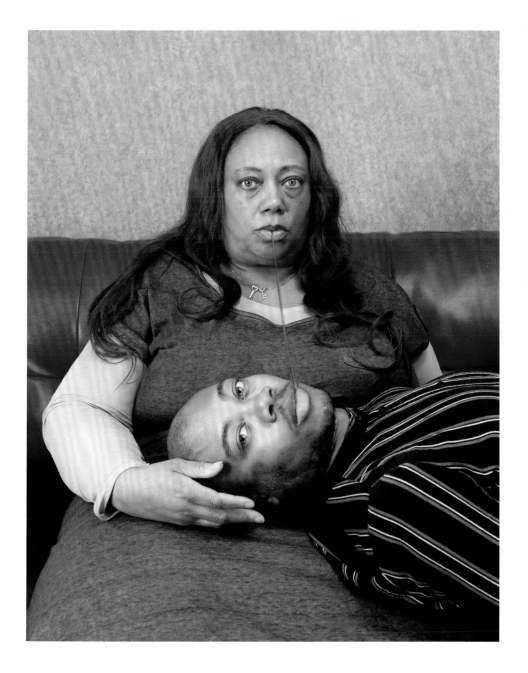

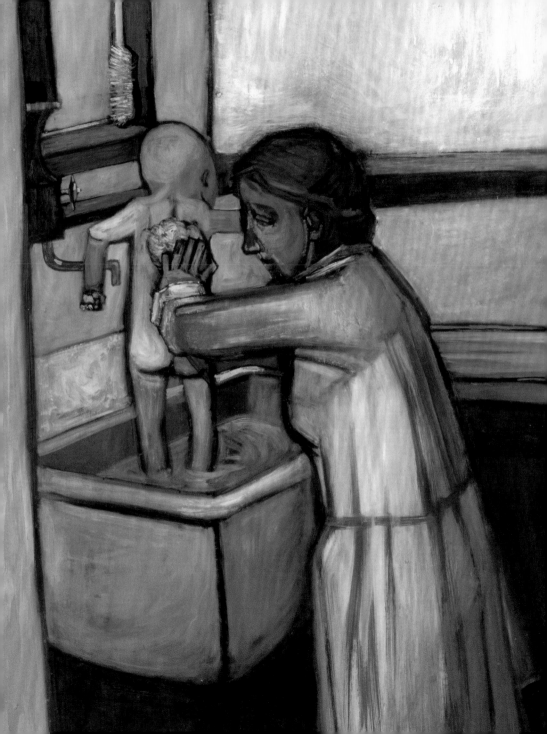

Nurturing, Protecting Mothers

Arthur Boyd Houghton 1836–75
Mother and Children Reading c.1860
Oil paint on canvas 30.5 × 24.8

In this Victorian parlour scene a mother and her two children enjoy a storybook. They are surrounded by toys, and behind them a father or grandfather figure reads the newspaper. These middle-class children likely had a nanny or nursery maid who would take on the majority of childcare responsibilities, leaving the mother to enjoy a special moment, such as reading a bedtime story. The family appear to be healthy, relaxed and contented.

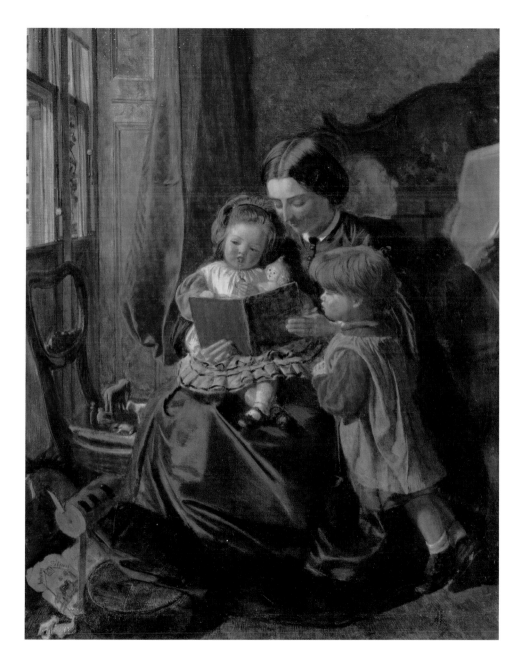

Thomas Faed 1826–1900
Highland Mother, exhibited 1870
Oil paint on canvas 26.7 × 20.3

The mother in this painting is a picture of self-sacrifice. A young
woman breastfeeding her baby, she is depicted as sitting
outdoors in a rugged highland landscape, wearing her outdoor
cloak and bonnet, yet baring her breasts to the elements.
She may be tired and hungry. Perhaps this highland mother
symbolises the human will to survive in harsh conditions.

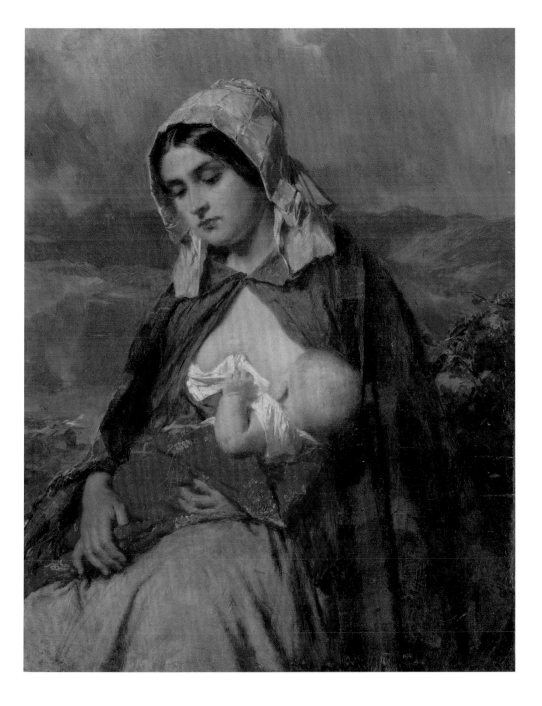

Jean Marchand 1883–1941
Maternity 1921
Oil paint on canvas 147 × 97.8

Originally titled *Woman Suckling her Child*, this picture shows
a mother and infant in harmony with each other and with their
surroundings. Set against a bright blue sky on a warm day, the
mother leans in towards her infant, offering and positioning her
breast. The young woman was reportedly a model who posed
for Marchand – a cubist painter associated with the British
Bloomsbury group.

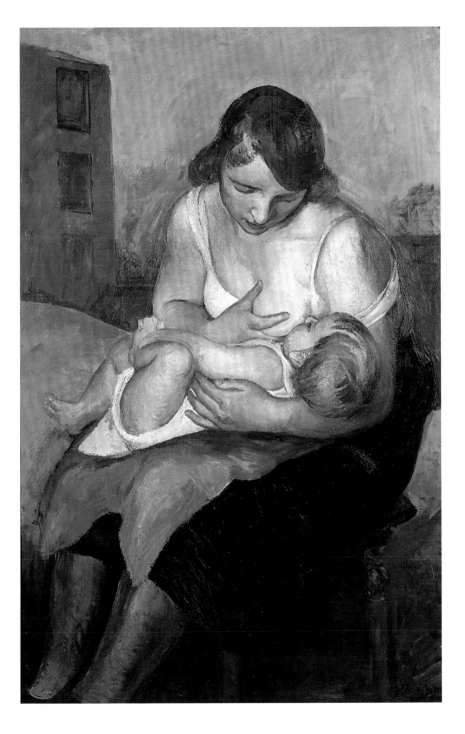

Dorothea Lange 1895–1965
Migrant Mother, Nipomo, California 1936
Gelatin silver print on paper 35.5 × 28

Dorothea Lange's photograph of a poverty-stricken mother and
her unkempt children has become an iconic image of the Great
Depression. Lange was employed to photograph farm labourers
for a North American federal government agency called the
Resettlement Administration. Lange did not name the woman
in the photograph, who is simply classified as 'Migrant Mother'.
While it was originally assumed that she was of European
descent, later accounts suggest that she may have been Native
American. Her children turn their faces away from the camera
and she looks into the middle distance with a furrowed brow,
apparently bearing the weight of the world upon her shoulders.

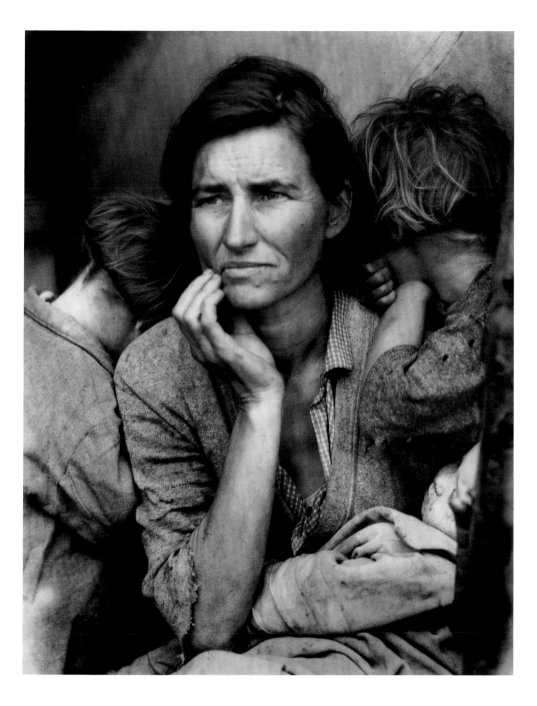

Henry Moore 1898–1986
Upright Internal/External Form 1952–3
Plaster 195.6 × 67.9 × 69.2

Though Henry Moore made many mother and child sculptures, this plaster form is perhaps his most abstract take on the subject. The external form appears to be protecting the internal form, as if in a cocooning, maternal embrace. As Moore recalled: 'I have done other sculptures based on this idea of one form being protected by another . . . I suppose in my mind was also the Mother and Child idea and of birth and the child in embryo. All these things are connected in this interior and exterior idea.'[13]

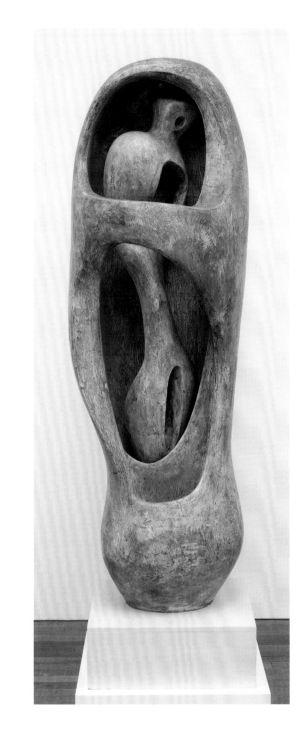

Jack Smith 1928–2011
Mother Bathing Child 1953
Oil paint on board 182.9 × 121.9

This is the painting that inspired the label 'Kitchen Sink',
which was applied to a group of British artists who looked to
the ordinary and everyday for inspiration. Here, a mother gives
her baby a sponge wash. Jack Smith uses a reduced palette
of browns and blacks and a heavy line to describe the scene.
The mother looks weary, going through the motions of daily
domestic drudgery.

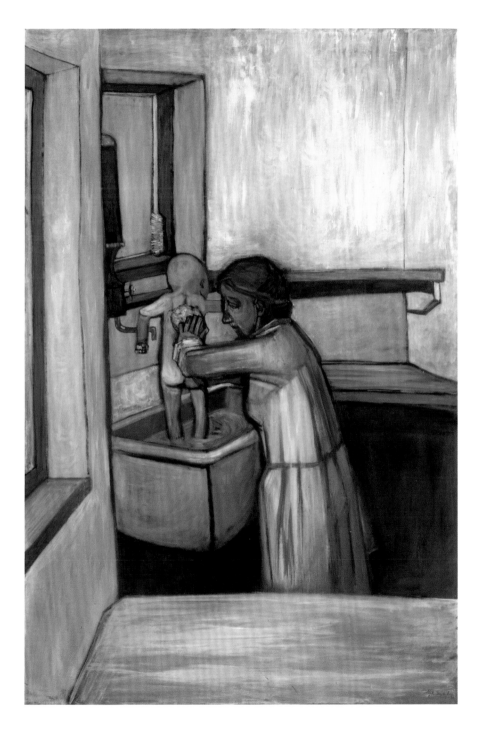

The Hackney Flashers Collective 1974–80
Who's Holding the Baby? 1978
Black and white photograph 25.2 × 20.2

The Hackney Flashers were a group of women artists who
worked together in the poorest neighbourhoods of London's
East End on feminist, agit-prop projects and exhibitions. *Who's
Holding the Baby?* was the title of their second exhibition, which
focused on the lack of free and affordable childcare for working
women and the impact this had upon their lives. Using collage,
illustration, photography and graffiti, the artists raised awareness
of this issue. They also proposed solutions and outlined
examples, documenting a local community nursery in Hackney.

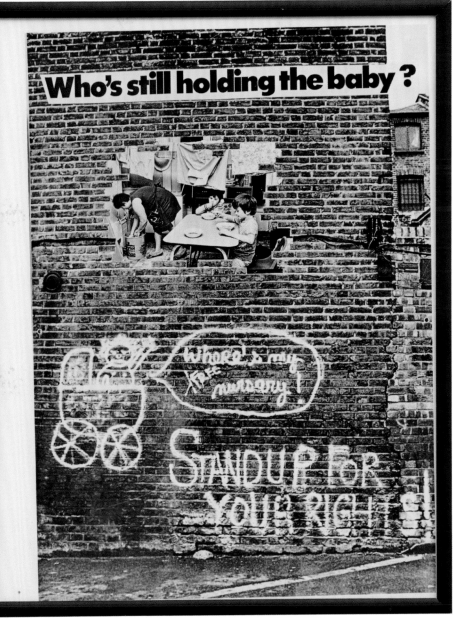

Louise Bourgeois 1911–2010
Maman 1999
Steel and marble 927.1 × 891.5 × 1023.6

Motherhood is one of the central themes of Louise Bourgeois's
work, and this is arguably her strongest sculptural statement.
Bourgeois's giant spider looms over us threateningly. *Maman*
(the French word for 'mother') refers to the artist's own mother,
an industrious seamstress who worked for the family tapestry
restoration business. This spider is also an archetypal mother
and a symbol of motherhood itself. In her under-body sac
she carries seventeen marble eggs which she needs to protect.

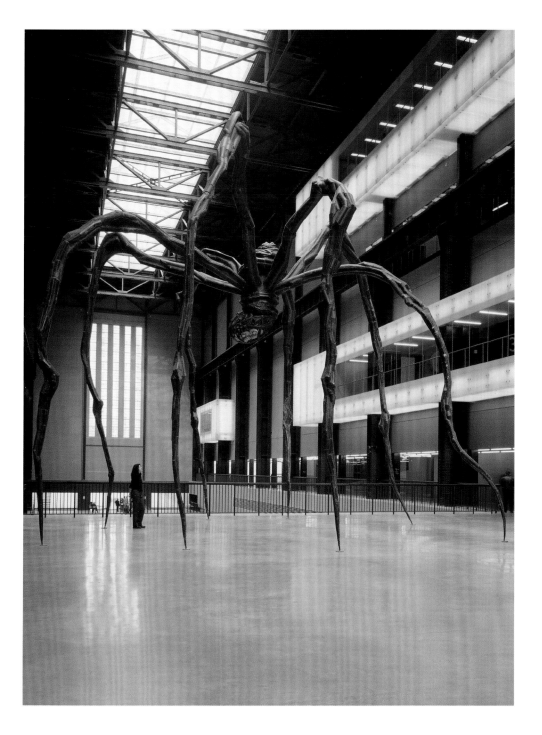

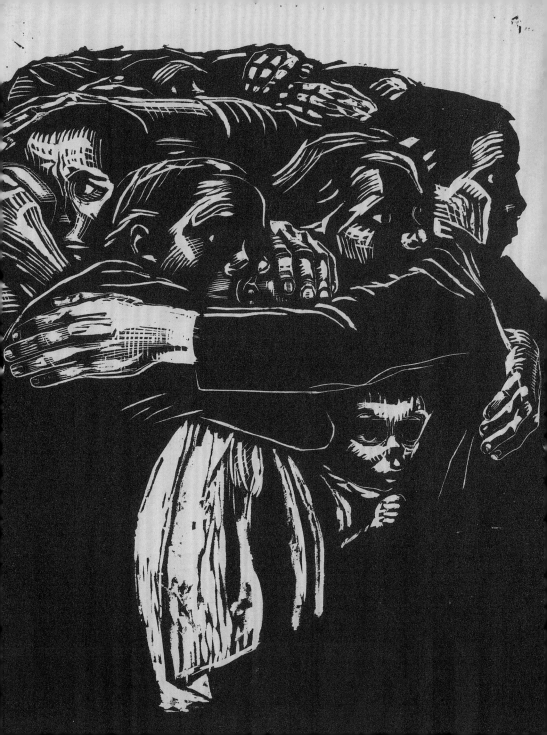

Grieving Mothers

Frank Holl 1845–88
Hush! and *Hushed*, both 1877
Oil paint on canvas 34.3 × 44.5

In the Victorian era childhood death was very common,
particularly in poorer families. This pair of social realist
paintings show a mother and her older child stricken by the
sickness and death of her infant. In the first picture, poverty is
suggested by the woman's torn apron, the basic surroundings
and the cracked wooden crib, which stands like an ominous
gravestone beneath her watchful gaze. In the second painting,
the embers of the fire are dying and the infant is sadly hushed
too soon. The mother's pain is expressed through her body
language and the sombre mood of the picture.

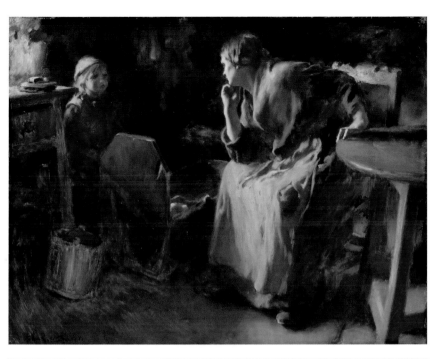

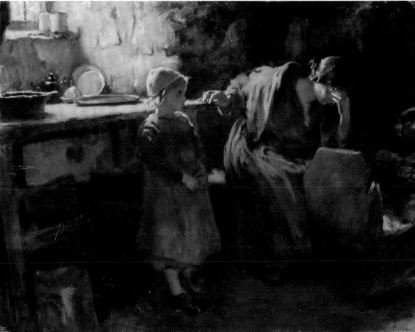

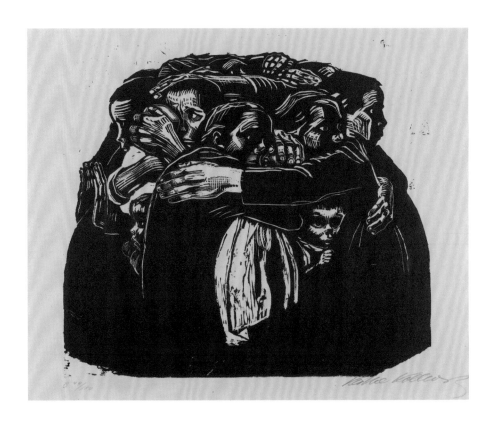

Käthe Kollwitz 1867–1945
The Mothers 1921–2, from the series *War*
Woodcut on paper 39 × 48

German expressionist Käthe Kollwitz's woodcut print presents
a powerful image of mothers united in grief. These women are
mourning the catastrophic losses of the First World War:
of sons and husbands lost in the trenches. The image is one
of a series of prints created by Kollwitz, whose own son was
killed at the Front in 1914 at the age of eighteen. Despite the
horror of the situation, the women huddle together in support
of each other.

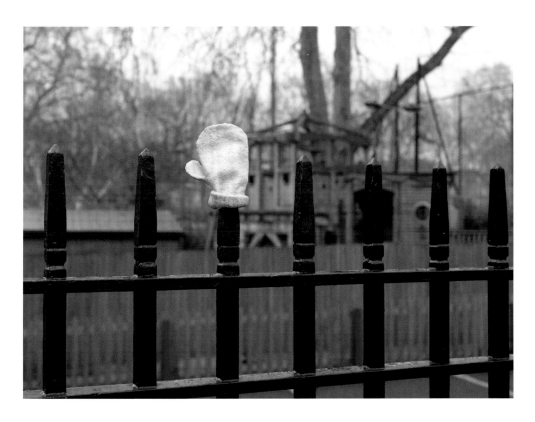

Tracey Emin 1963–
Baby Things, Mitten 2010
Patinated bronze 95 × 70 × 45

In 2007 Tracey Emin started to pick up and collect lost baby
items she found on the streets, such as mittens, comforters
or toys. Noticing the feelings of empathy aroused by these
orphaned mittens and socks, unlikely to be reunited with their
twins, she later cast them in bronze and installed them in public
places. They remain forever lost, yet hopeful. This mitten is fixed
to the railings outside the Foundling Museum in London, at
the site of Thomas Coram's historic orphanage for abandoned
children. Emin has spoken openly about the botched abortion
she underwent in 1994 and of the situation of being childless.

Titus Kaphar 1976–
Analogous Colors 2020
Oil paint on canvas 168 × 152

This painting by Titus Kaphar was printed on the cover of *Time* magazine following the death of George Floyd in 2020. The artist said: 'In her expression, I see the Black mothers who are unseen, and rendered helpless in this fury against their babies.'[14] The painting is one of a series depicting Black mothers in which Kaphar has cut out the children from the canvas to reveal the blank gallery wall behind. It is often assumed that the blanked-out children in the series do not belong to the women depicted (perhaps because of the history of Black women's servitude and their roles as mammy, nanny, housemaid, etc), but there can be no doubt that the mother in this particular picture is deeply grieving the missing child erased from her arms.

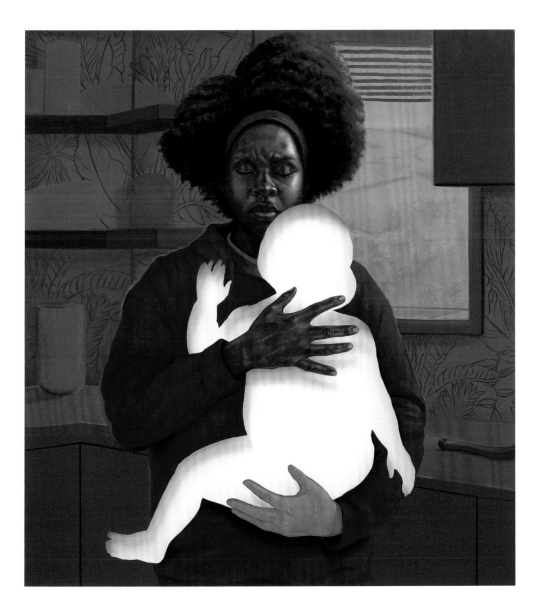

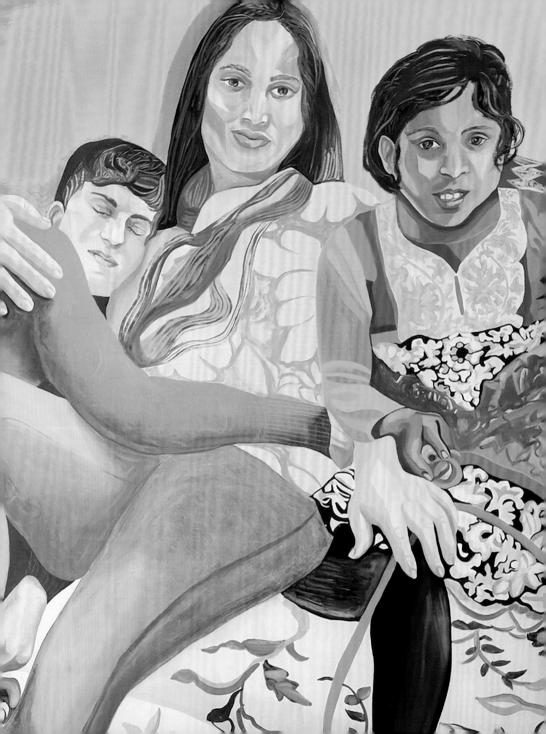

Proud Mothers

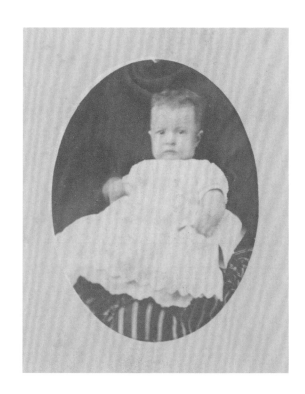

Unknown photographers
Hidden Mothers 1800s

With the advent of photography and the high rates of infant
death, baby photographs were popular in the Victorian era.
Due to the slow shutter speeds, however, it was often necessary
for the mother or nanny to be present within the frame, to keep
the child still. It was therefore common for the mother to hide
behind chairs and drapery, giving the resulting photographs a
somewhat sinister aspect to the contemporary eye. The
Victorian equivalent of using your child's photograph as a profile
picture on social media, the 'hidden mother' photographs speak
volumes about the pride and selflessness of new mothers, who
in this case have erased themselves from the pictures.

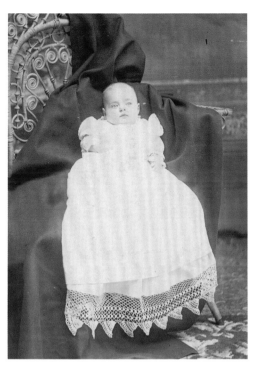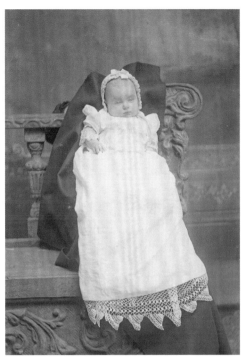

William Rothenstein 1872–1945
Mother and Child 1903
Oil paint on canvas 96.9 × 76.5

This painting shows the artist's wife Alice and their two-year-old son John in the sitting room of their large house in Hampstead, North London. A picture of motherly pride, Alice holds up her young son on her lap and is clearly enjoying a moment with him. She was likely pregnant at this time with John's younger sister, though her second child died shortly after birth. John Rothenstein grew up to become an art historian, and was Director of the Tate Gallery from 1938 to 1964.

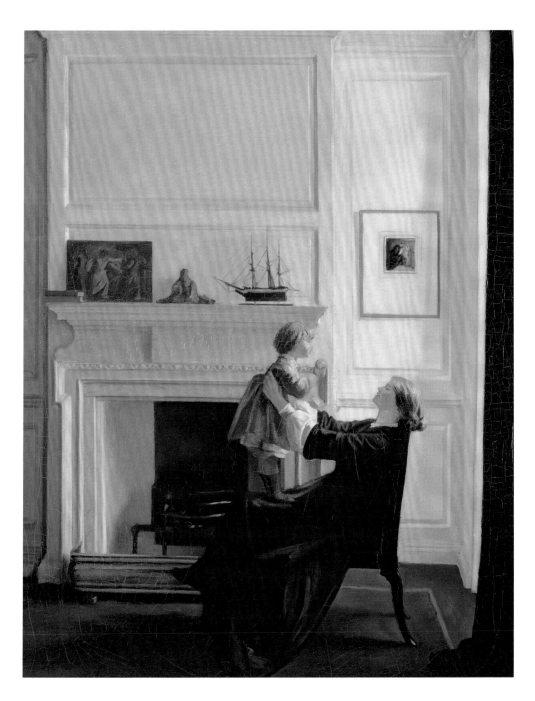

Dennis Morris 1960–
'Mother's Pride' Hackney 1976
Gelatin silver print on paper 27.5 × 40.5

Taking its title from a well-known brand of sliced bread, this
image shows a smartly dressed mother and her two children
posing for the camera in a domestic setting. Jamaican-born
British photographer Dennis Morris documented Black
diasporic communities in Dalston, London, where he grew up
in the 1970s. Despite the harsh realities of racist discrimination
and poverty that accompanied life in the UK, the photographer
recalls a sense of pride in the home and a desire to belong.
This mother gazes at her young daughter with an expression
of pride and barely suppressed emotion.

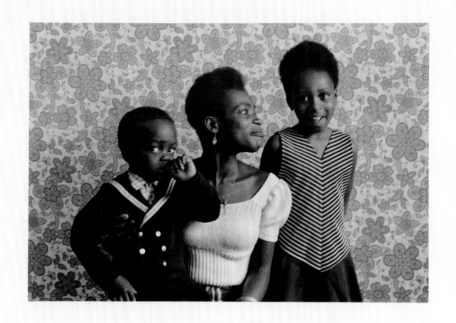

Richard Hamilton 1922–2011
Mother and Child 1984
Collotype and screenprint on paper 61.2 × 56.9

A mother holds the hand of her toddler in this sunny print
by Richard Hamilton. Her head has been cropped out of the
picture, while the child is in the centre, suggesting that the
image is drawn from an amateur photograph, perhaps aiming
to capture the toddler's first steps. Looking down from an adult
vantage point, the photo may have been taken by a family
member or friend. Washy areas of colour suggesting trees
and shadows spill over the picture's edge. In this perfectly
ordinary family outing, the mother is peripheral to the scene
– a supporting act and a hand to hold.

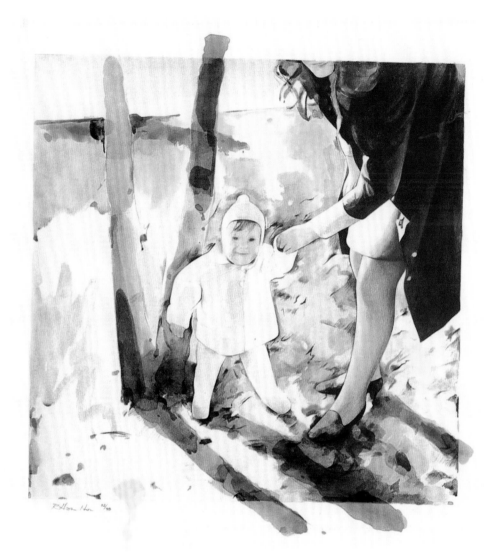

Aliza Nisenbaum 1977–
Susan, Aarti, Keerthana and Princess, Sunday in Brooklyn 2018
Oil paint on canvas 145 × 162.6

This vibrant portrait of a contemporary, two-mother family
shows a couple and their mixed-heritage daughters. The family
are relaxing on a Sunday in their apartment in Brooklyn, New
York. The scene is cosy, and the sitters show their affection
for one another through touch and physical closeness. Their
clothing, the textiles on the couch and floor, and the walls are
as eclectic as the family members. Nisenbaum first met Susan
while completing a residency for Immigrant Women Leaders
in 2015. The artist got to know the family, who she said, 'came
together through immigration, adoption, and New York City and
are deeply committed to social justice and racial equity – both
women have devoted their careers to advancing education and
human rights'.[15]

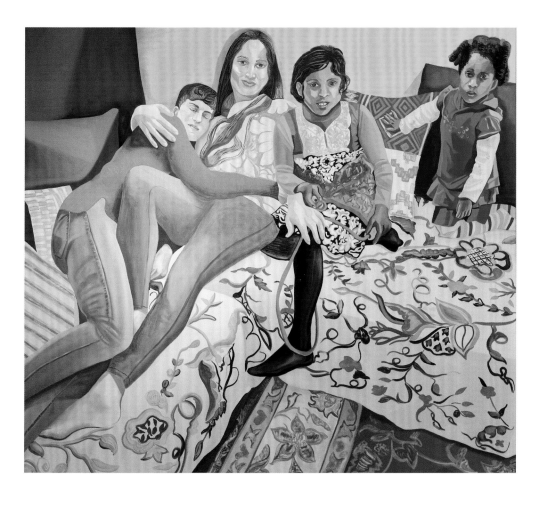

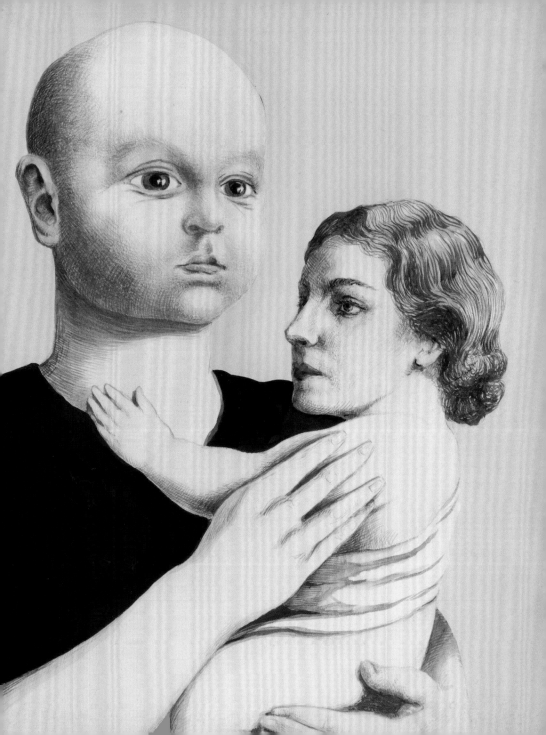

Divided Mothers

René Magritte 1898–1967
The Spirit of Geometry 1937
Gouache on paper 37.5 × 29.2

In this surreal vision of motherhood, René Magritte has exchanged the heads of the mother and her baby. Though the painting was originally titled *Maternity*, the more enigmatic *Spirit of Geometry* could suggest that the relative scale and position of the pair describes their relationship. Perhaps the woman feels that her demanding baby is in charge and that her selfhood is diminished. Or perhaps her spirit is happily nurtured by the child who looms so large in her life.

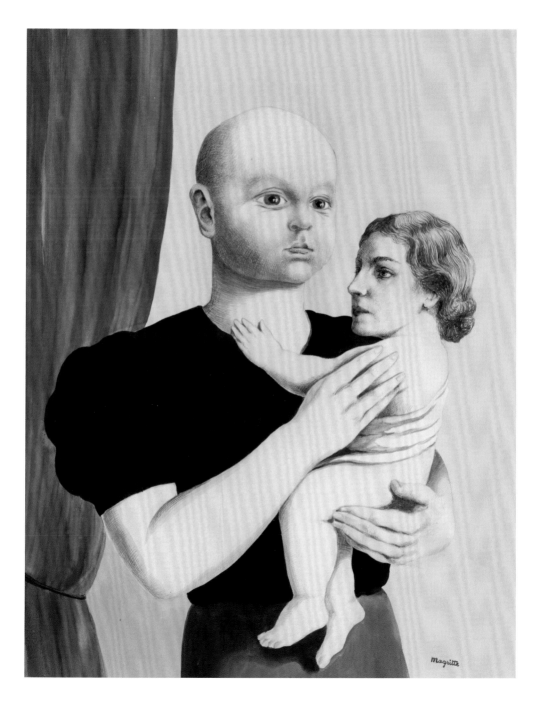

Dorothea Tanning 1910–2012
Maternity 1946–7
Oil paint on canvas 142 × 121

American surrealist Dorothea Tanning paints a grim picture of
maternity here. A forlorn-looking mother in ragged attire stands
between two open doorways in a desert landscape. She holds
her baby, while a small dog at her feet has a human child's face.
Through the most distant door a set of billowing sails forms the
shape of the female reproductive system. Tanning chose not to
go through the doorway of motherhood, preferring to dedicate
herself to her work, though she may have been emotionally
divided when painting this picture, which shows maternity as
a stormy and bewildering mental space.

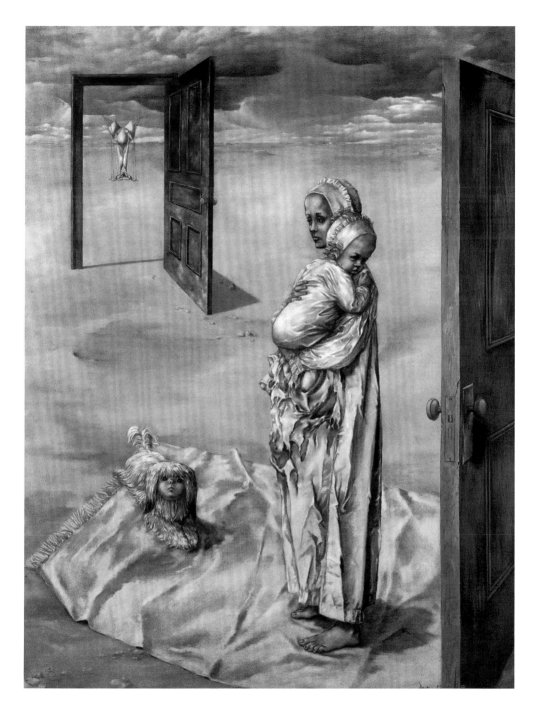

Mona Hatoum 1952–
Measures of Distance 1988
Video; colour and sound (mono) 15 min, 35 sec

Mona Hatoum was separated from her mother in 1975 when
war broke out in Lebanon. *Measures of Distance* is a video
exploring the intimate relationship between Hatoum and her
mother, and the effects of displacement and exile. Hatoum
reads letters from her mother, translating them into English.
As she does this, the hand-written Arabic script floats across
the screen over images of her mother's naked body in the
shower. The artwork breaks taboos about maternal sexuality
and challenges stereotypical views of Arab women.

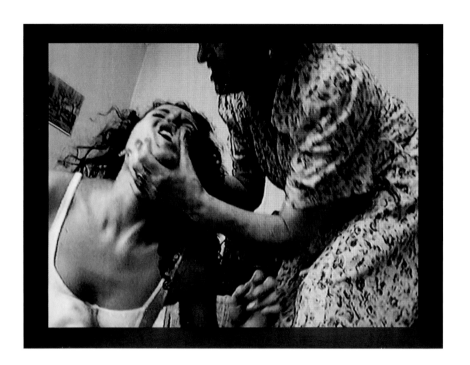

Gillian Wearing 1963–
Sacha and Mum 1996
Video; projection, black and white, sound 4 min, 30 sec

Gillian Wearing's short but intense video *Sacha and Mum*
explores the fine line between tenderness and violence, love
and pain. Playing the roles of mother and daughter, two actors
are caught in a physical and emotional struggle. The black-
and-white video plays forwards and backwards on a loop for a
four-minute, thirty-second duration. We are given no context
or clues about this abusive relationship and can only witness
the repetitive cycle.

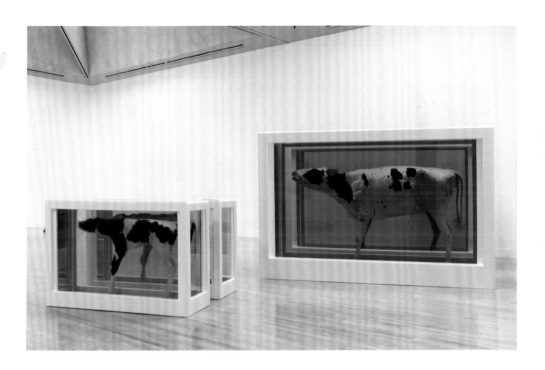

Damien Hirst 1965–
Mother and Child (Divided) 2007 (original 1993)
4 parts; glass, stainless steel, Perspex, acrylic paint, cow,
calf and formaldehyde solution; 2 parts 208.6 × 322.5 × 109.2;
2 parts 113.6 × 168.9 × 62.2

This bovine mother and her calf have been bisected
symmetrically and encased in formaldehyde so that we can see
the abject beauty of their separated carcasses from both the
inside and out. Damien Hirst has spoken of his memories of
Catholic school and the iconography of the Holy Mother and
Child. Though their flesh is preserved for us to see, this animal
pair offer no idealised unity, but rather confront us with the
brutal realities of division and death.

To my mother Jean Coxon
and all those who nurture others.

Ann Coxon

NOTES

1 Rozsika Parker, *Torn in Two: The Experience of Maternal Ambivalence*, London 1995, p.2.

2 At the time of writing, transgender pregnancy is rare and, when it does occur, is usually in people born with a uterus.

3 Cyril Connolly, *Enemies of Promise, Part 2: Charlock's Shade*, London 1938. It is worth noting here that Connolly's misogynistic statement was in fact referring to the artist's wife and child as distractions (assuming that the artist is male).

4 See D.W. Winnicott, *Playing and Reality*, London 1971.

5 Watts, quoted in *Works of G.F. Watts RA*, exh. cat., London 1896–7.

6 Monica Sjoo, artist's statement: http://www.artcornwall.org/features/Monica_Sjoo_God_Giving_Birth.htm, accessed October 2022.

7 Quoted in *Illustrated Catalogue of Acquisitions 1986–88*, London 1996, p.239.

8 Ibid.

9 Magdalena Abakanowicz, *Fate and Art*, 2nd edn, Milan 2020, p.86.

10 Barbara Hepworth, in an interview for the *Observer*, 1964.

11 Email correspondence with Tate curator Laura Smith, 5 June 2017.

12 Quoted in Emily Dinsdale, in conversation with D'Angelo Lovell Williams, *DAZED*, 8 April 2020.

13 Henry Moore, cited in John Hedgecoe (ed.), *Henry Moore*, London 1968, p.198.

14 Titus Kaphar, *Time* magazine, June 2020.

15 Aliza Nisenbaum, quoted on Contemporary Art Society website: https://www.contemporaryartsociety.org/news/cas-news/us-painter-aliza-nisenbaum-commissioned-make-new-work-norwich-castle-museum-art-gallery-vn-xx-cas-scheme/, accessed October 2022.

INDEX OF ARTISTS

First published 2023 by order of the Tate Trustees
by Tate Publishing, a division of Tate Enterprises Ltd,
Millbank, London SW1P 4RG
www.tate.org.uk/publishing

A catalogue record for this book is available from the
British Library

ISBN 978 1 84976 837 5

Distributed in the United States and Canada by ABRAMS,
New York

Library of Congress Control Number applied for

Senior Editor: Emma Poulter
Production: Roanne Marner
Picture Researcher: Emma O'Neill
Designed by Sandra Zellmer
Colour reproduction by DL Imaging, London
Printed by Graphicom S.p.A, Italy

Front cover: Caroline Walker *Baby Layla* 2022
(detail, see p.59)
Frontispiece: William Rothenstein *Mother and Child* 1903
(detail, see p.107)
Page 4: Gerhard Richter *S with Child* 1995
(detail, see p.53)

Measurements of artworks are given in centimetres,
height before width and depth